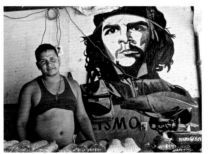

HAVANA

DE CUBA

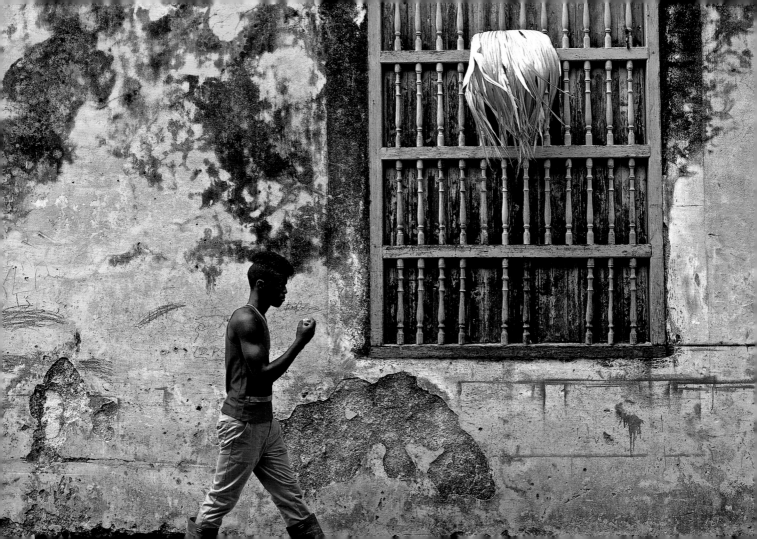

HAVANA DE CUBA

Marzena Pogorzały

PALLAS ATHENE

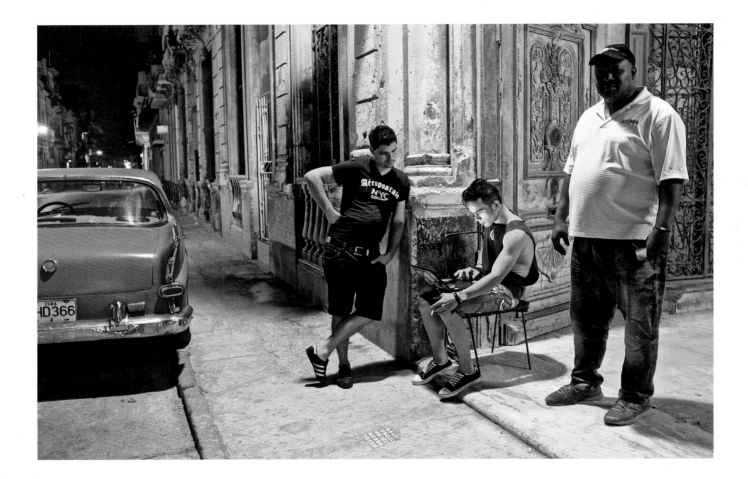

Cities, like dreams, are made of desires and fears,
even if the thread of their discourse is secret,
their rules are absurd, their perspectives deceit-
ful, and everything conceals something else.

Italo Calvino, *Invisible Cities*

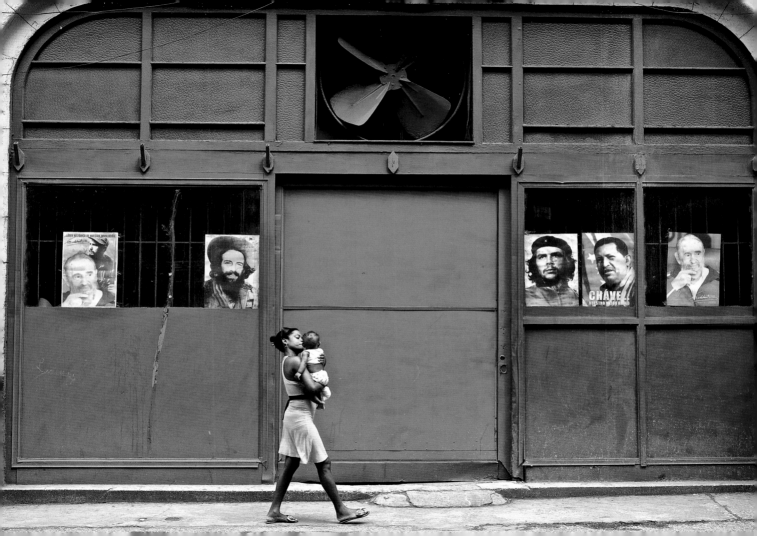

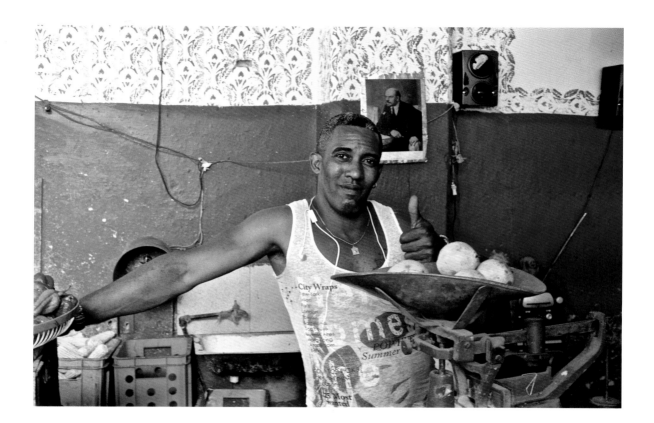

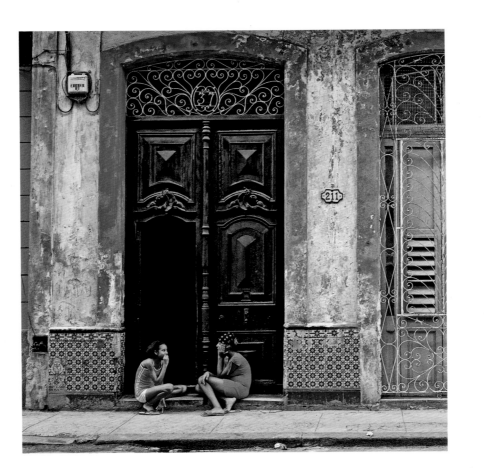

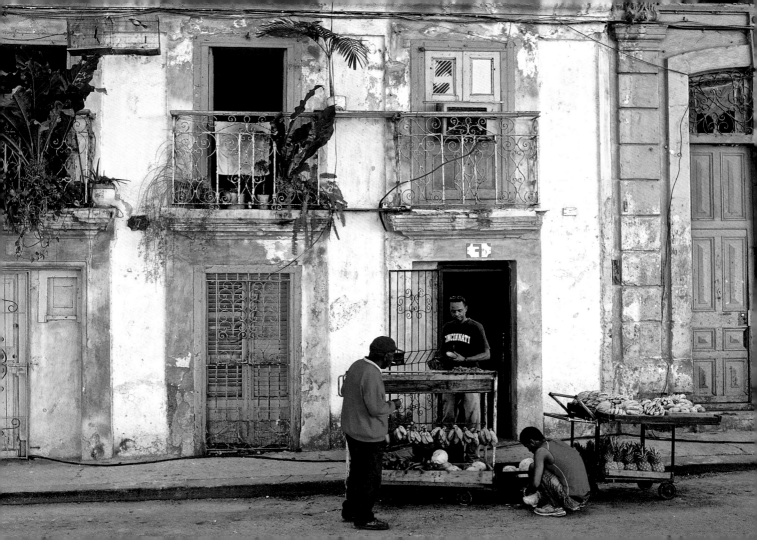

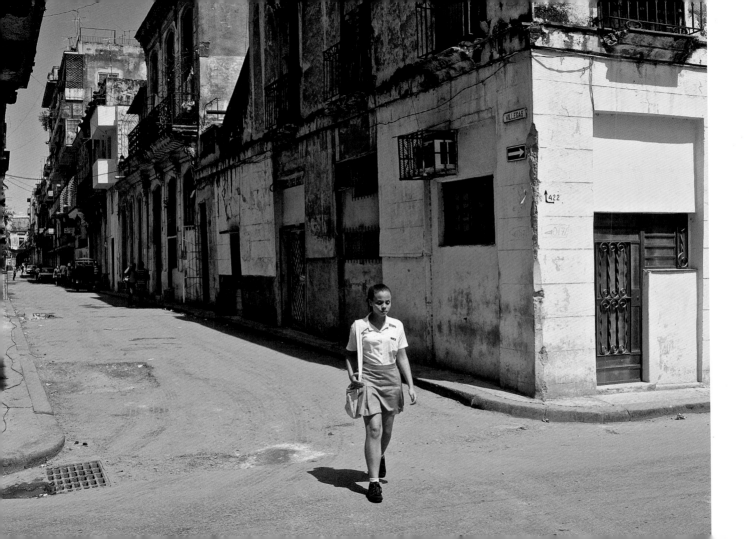

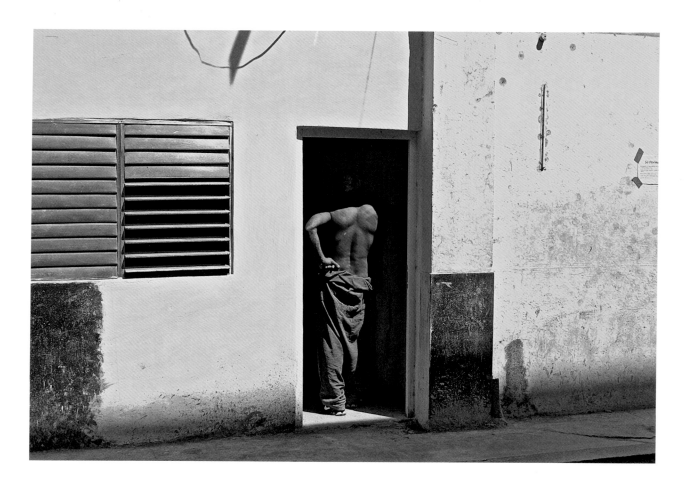

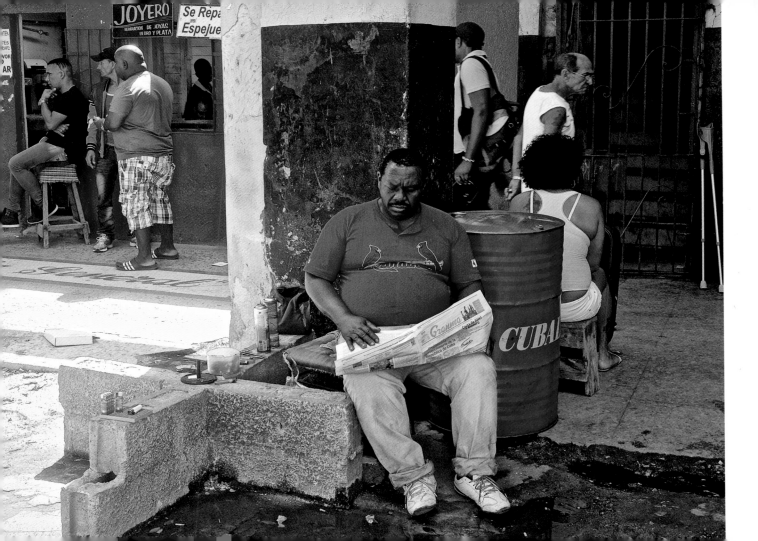

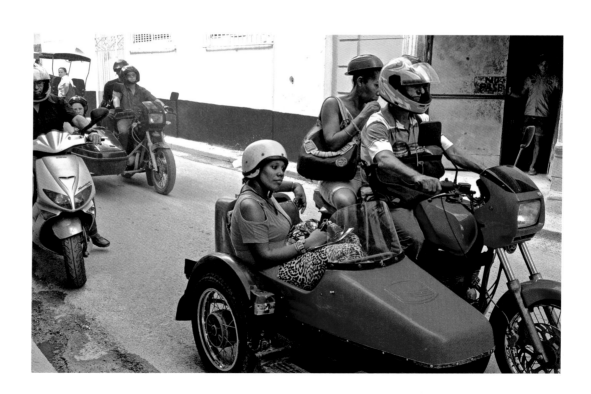

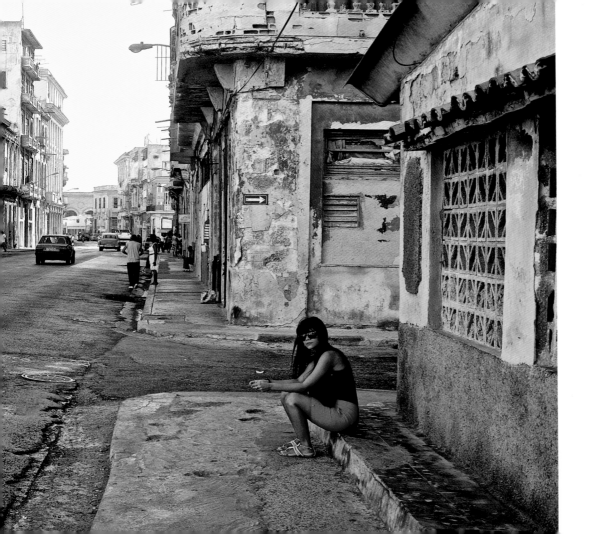

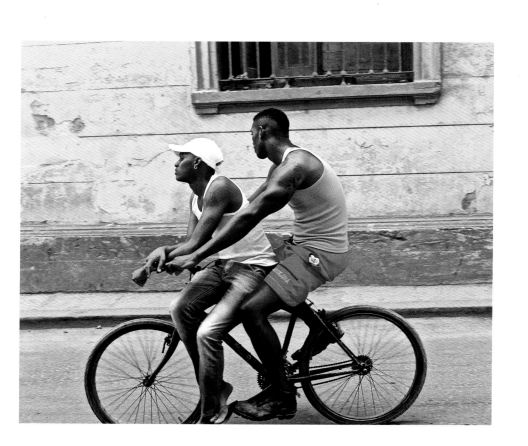

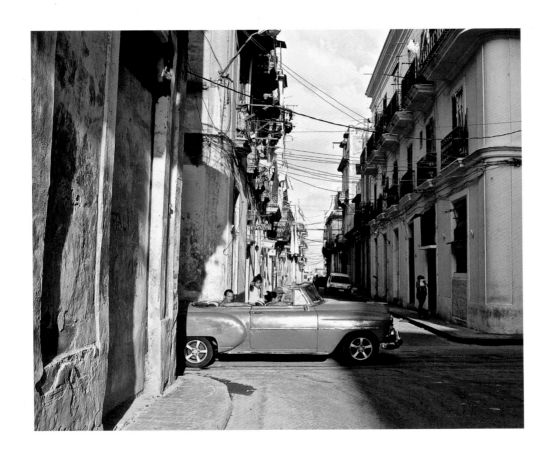

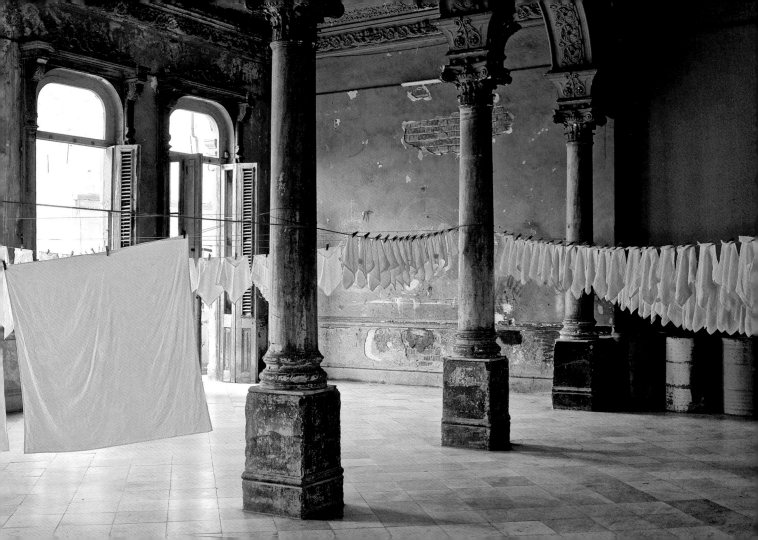

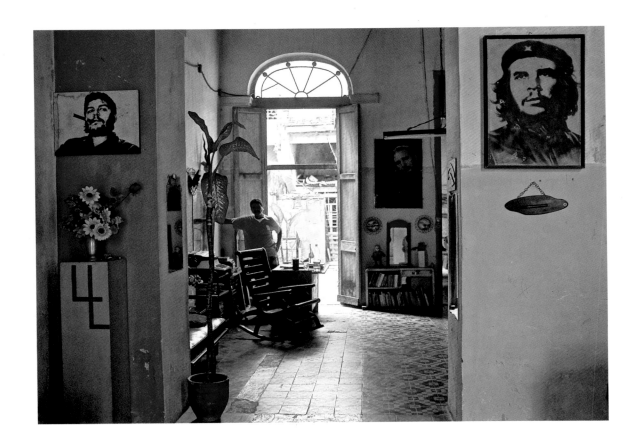

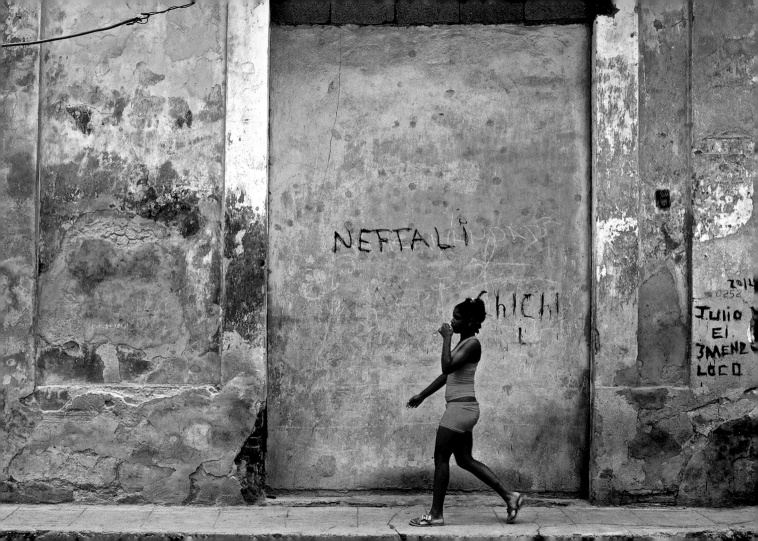

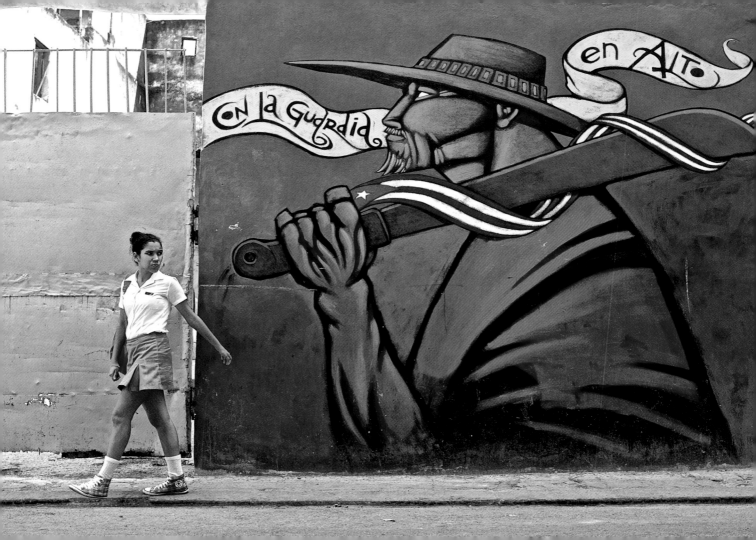

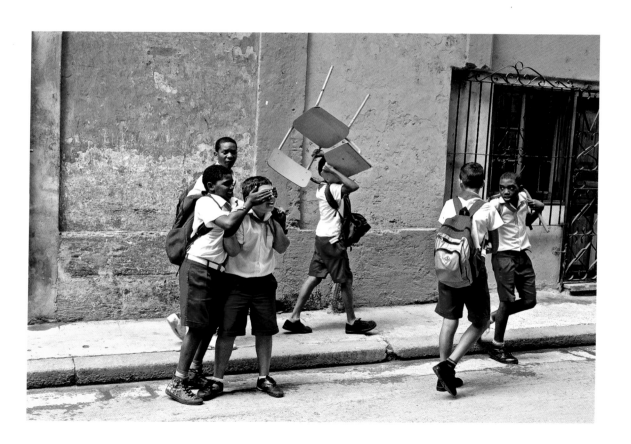

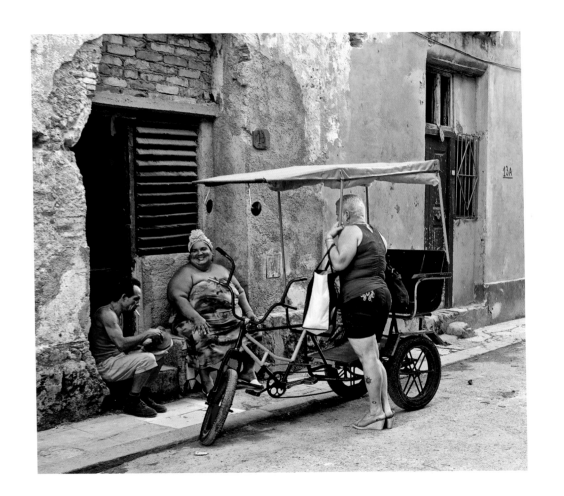

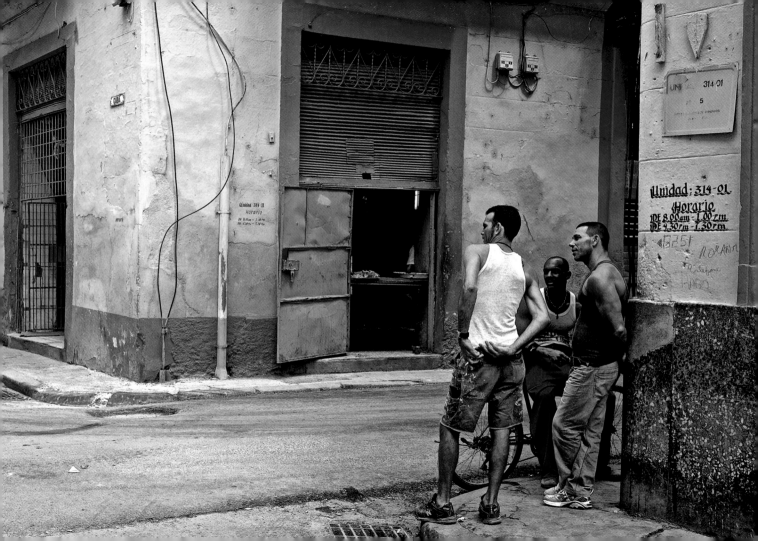

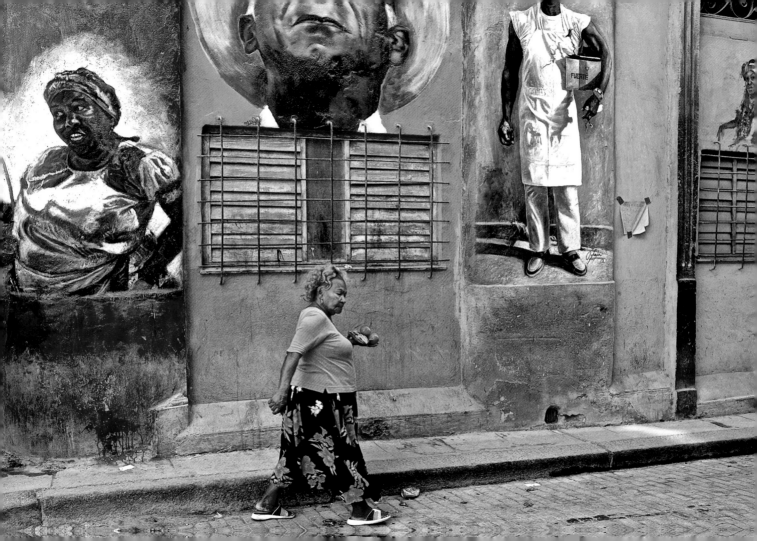

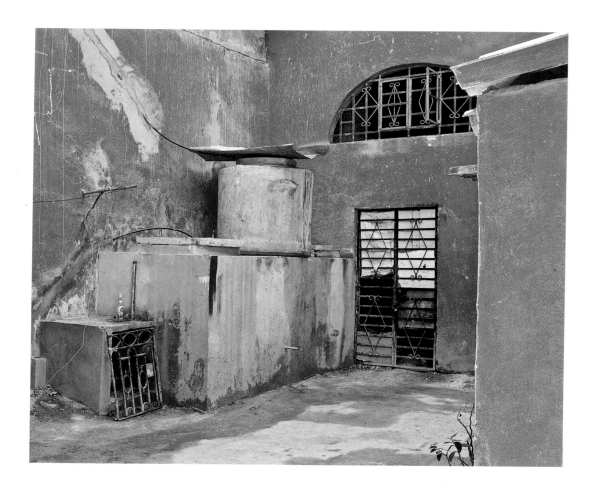

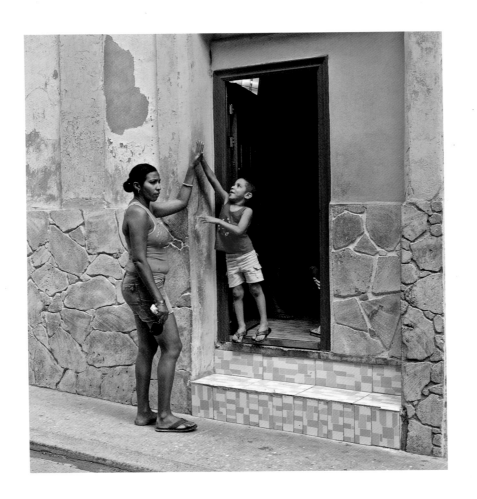

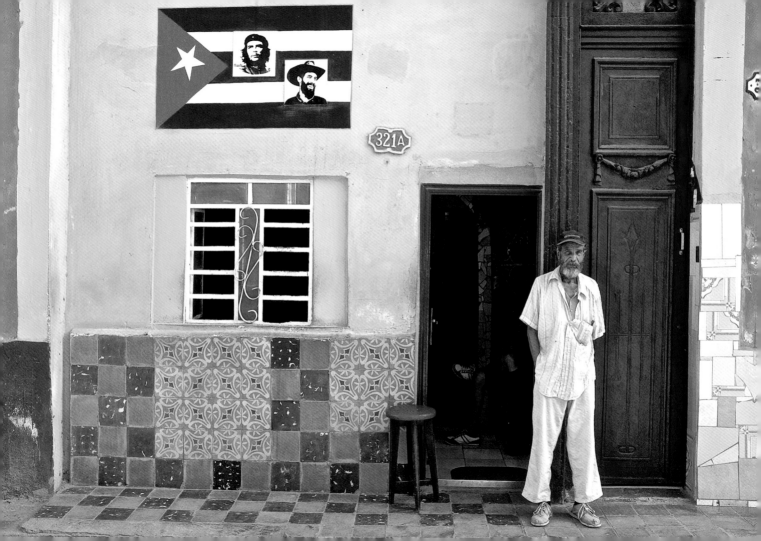

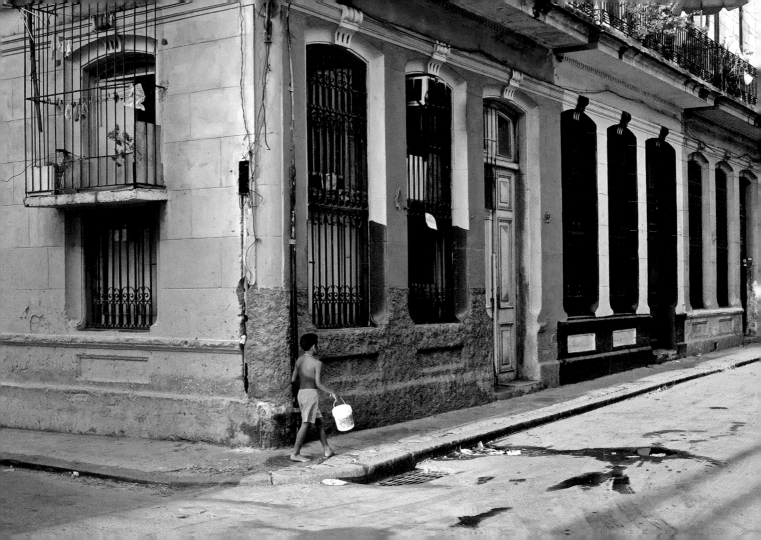

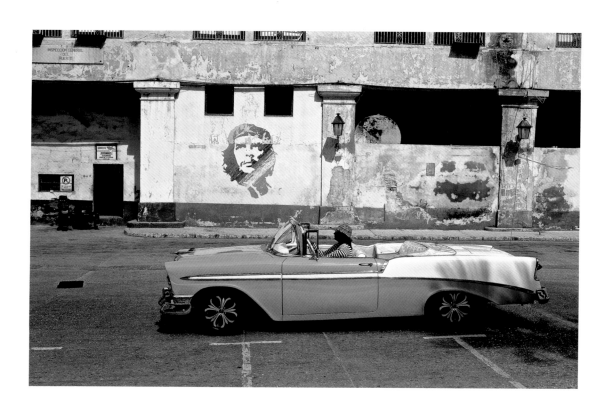

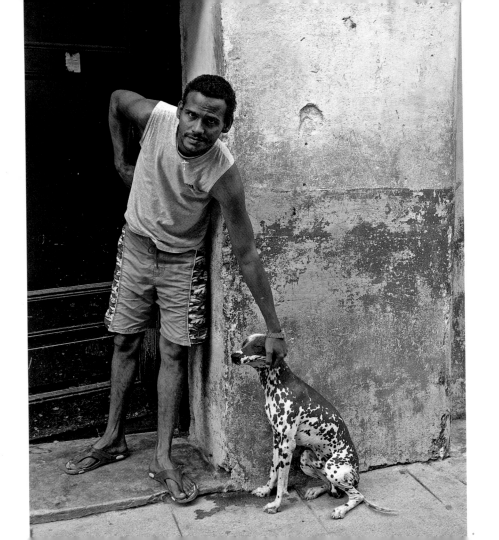

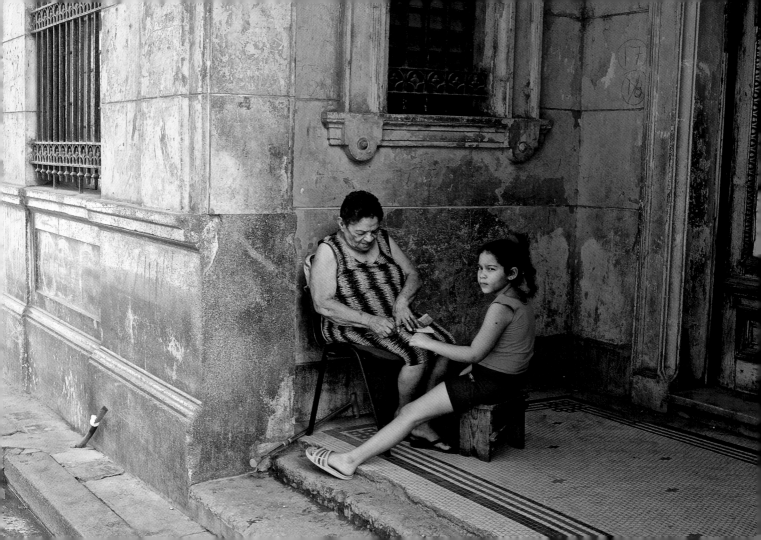

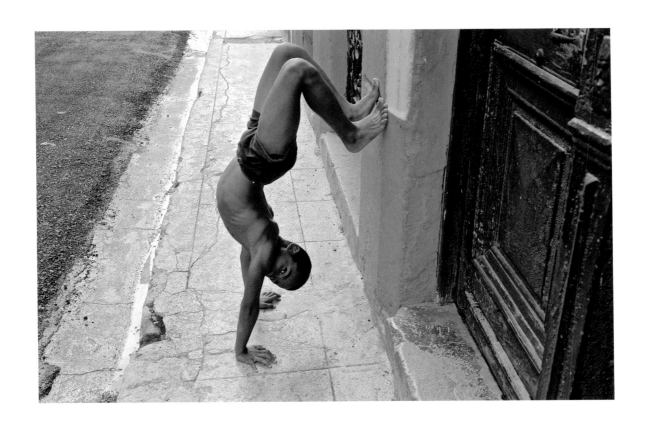

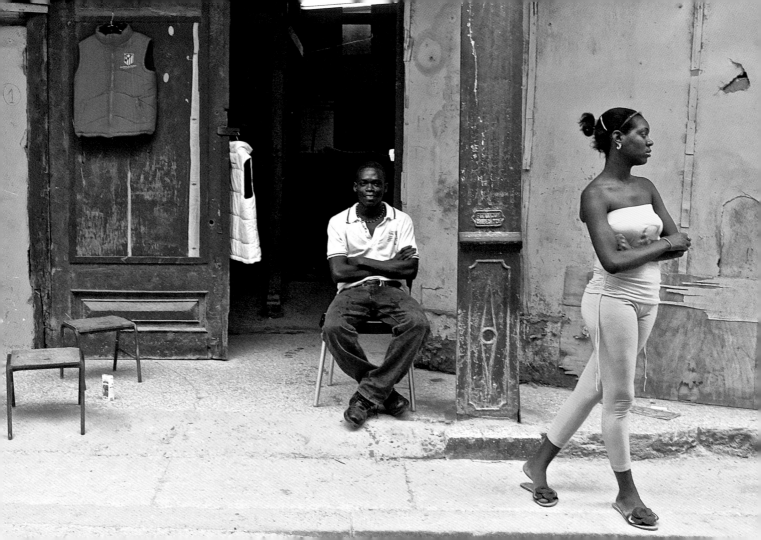

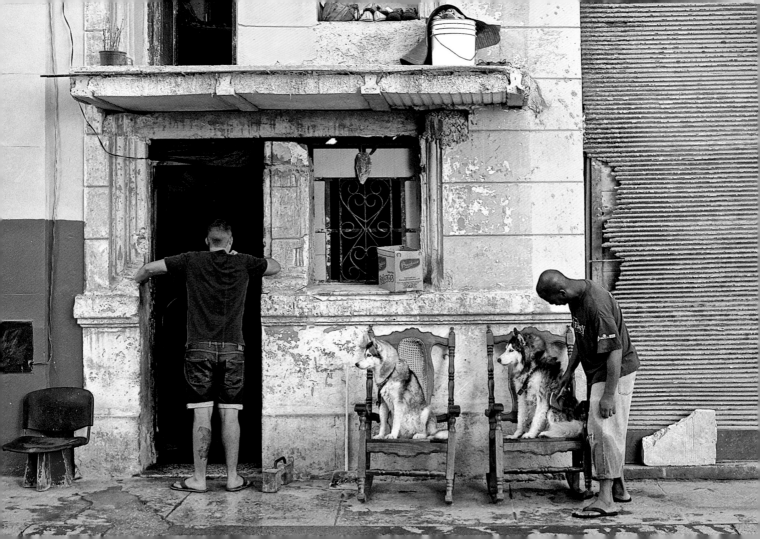

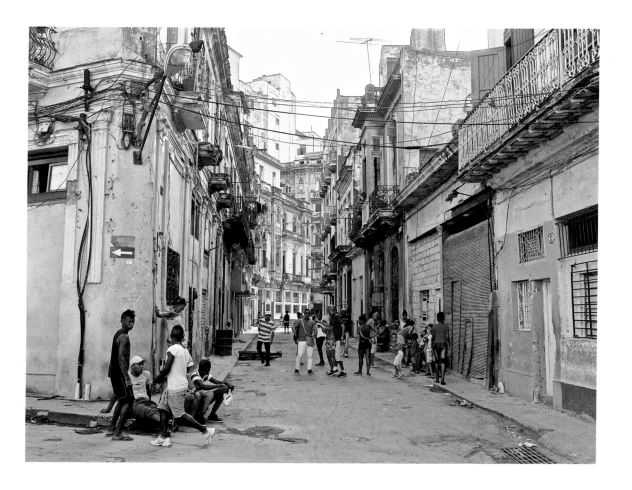

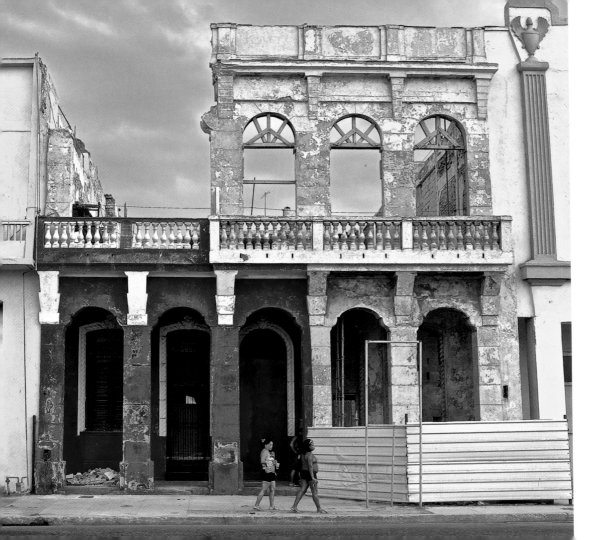

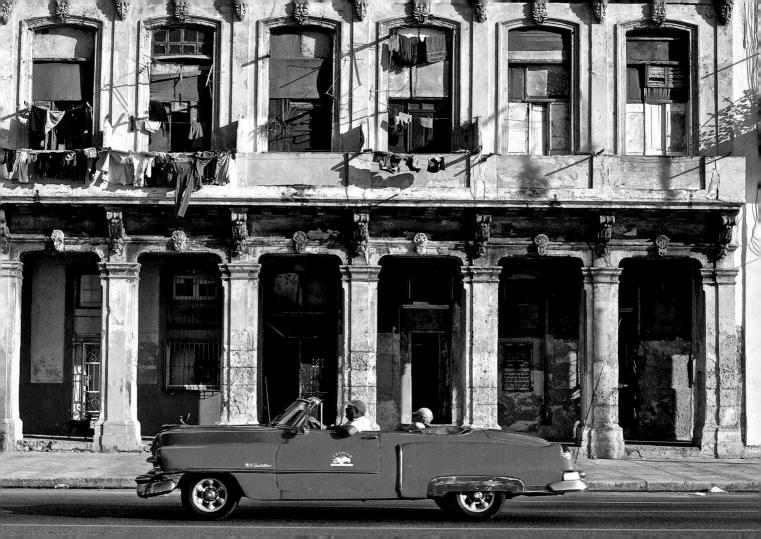

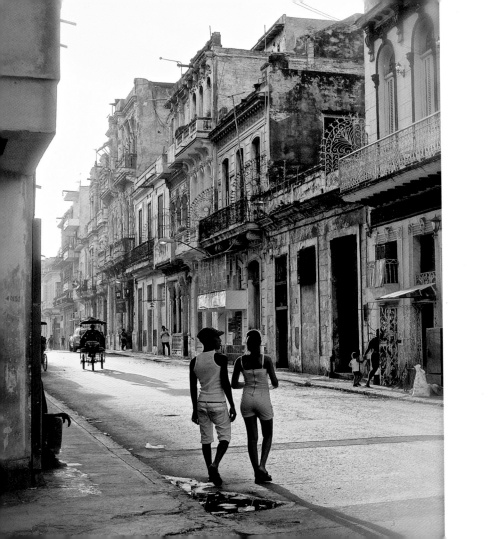

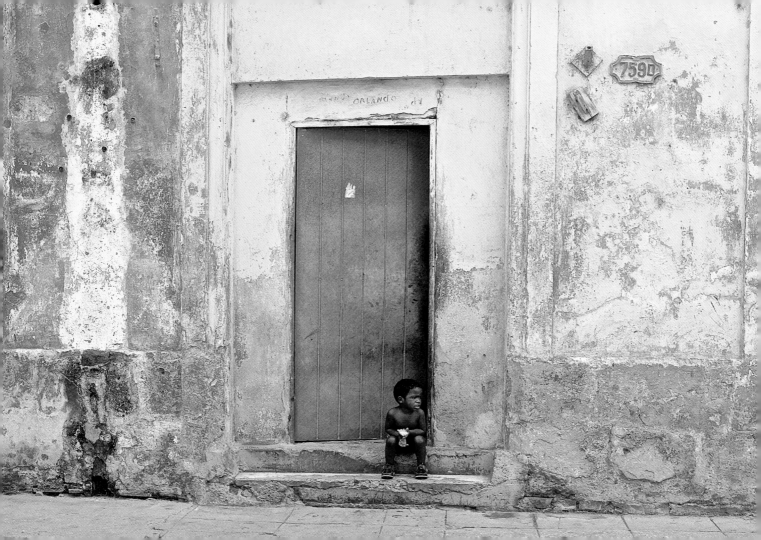

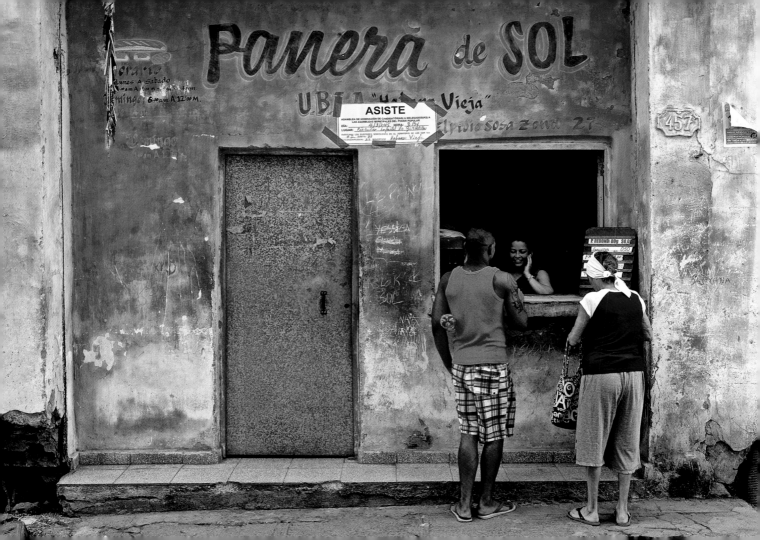

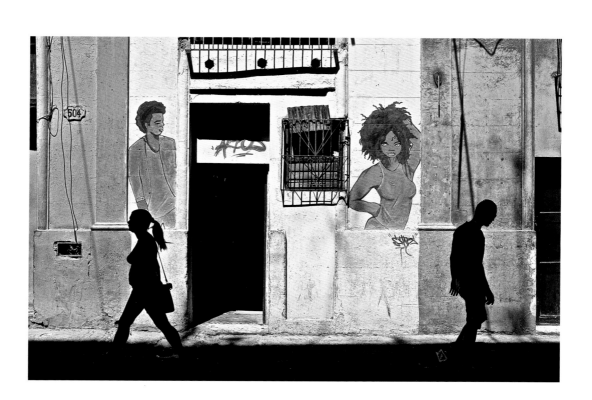

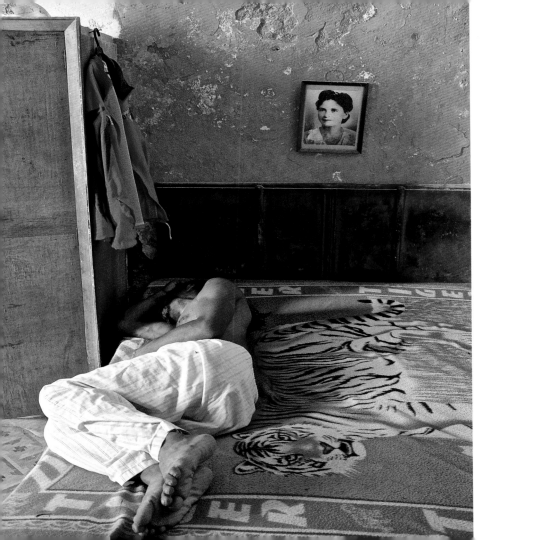

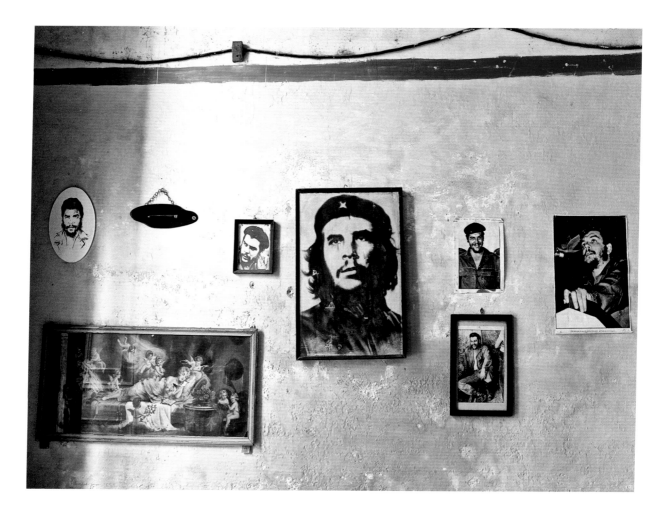

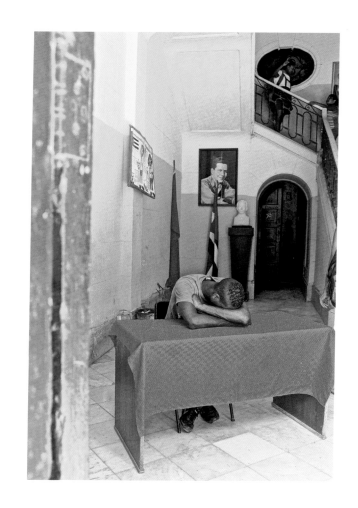

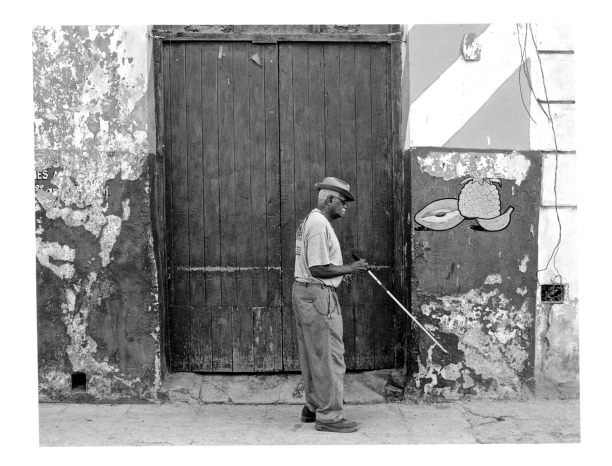

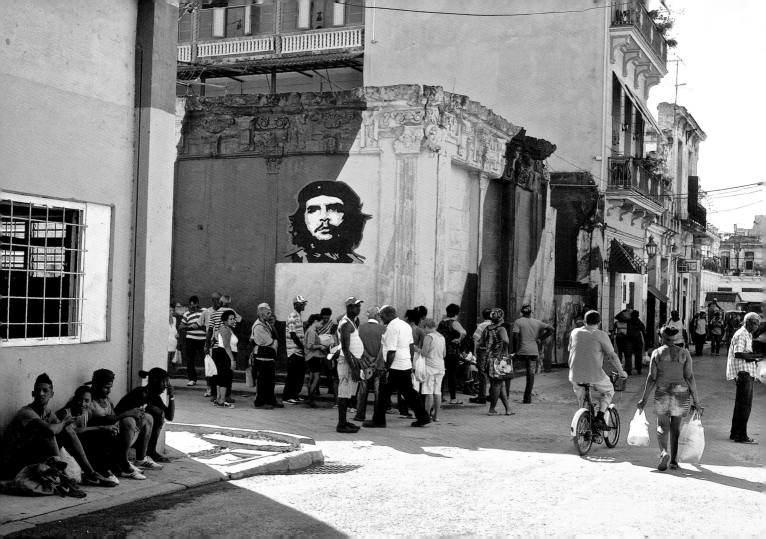

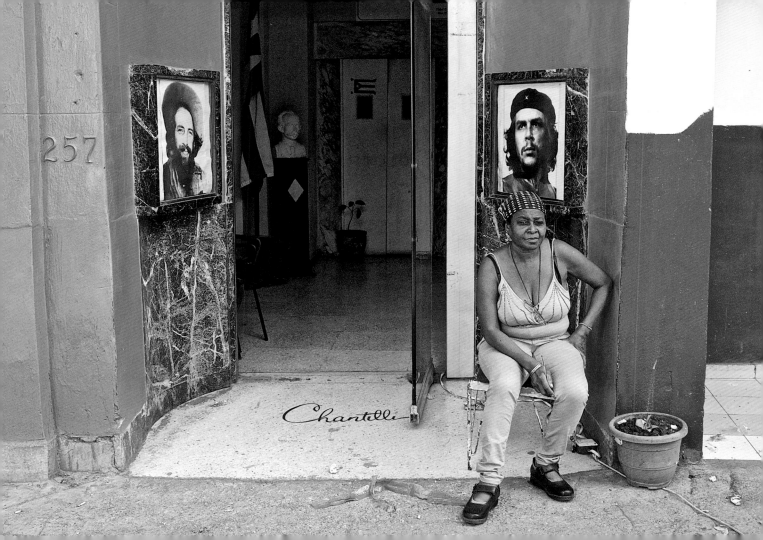

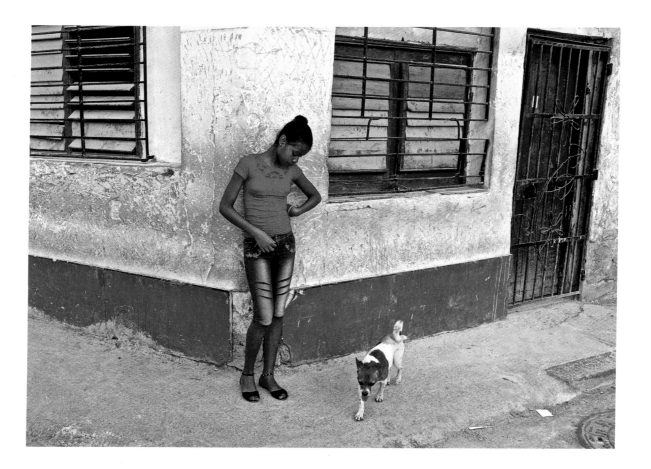

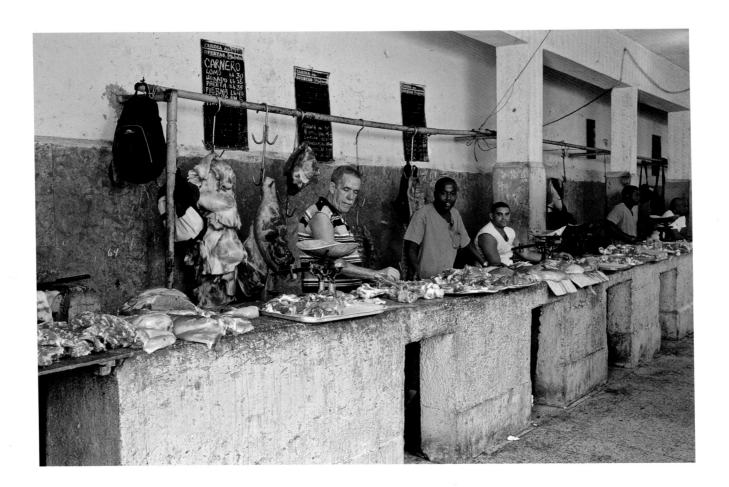

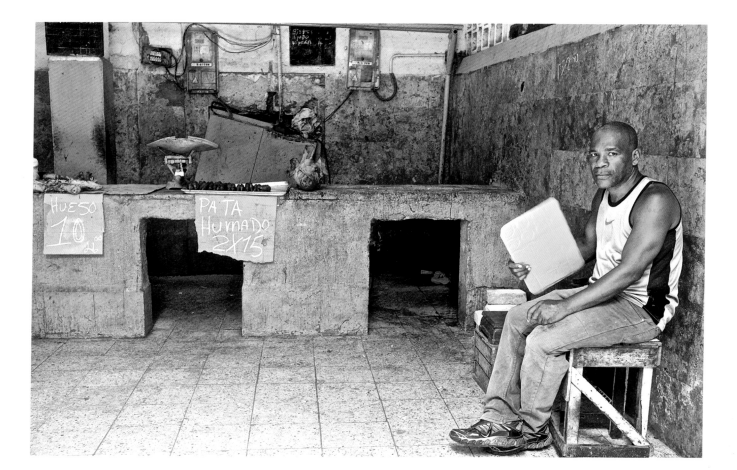

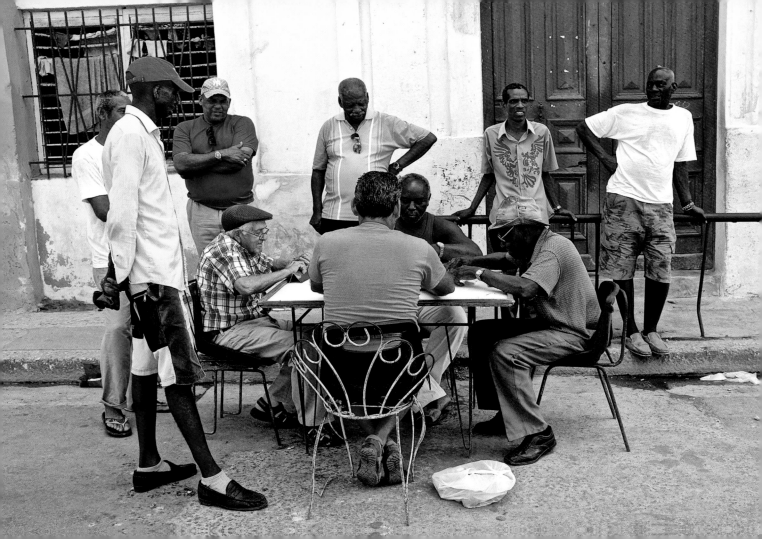

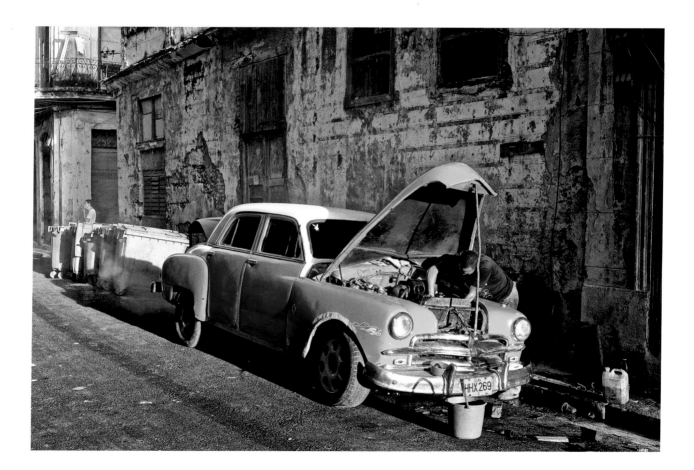

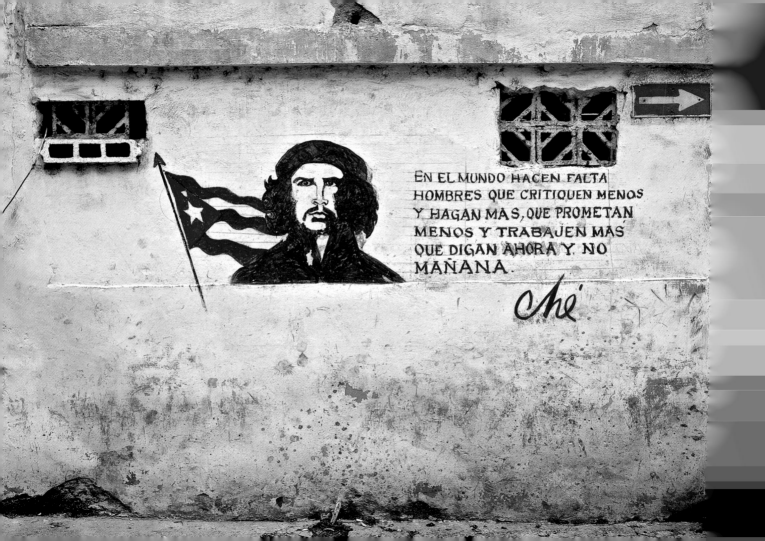

EN EL MUNDO HACEN FALTA
HOMBRES QUE CRITIQUEN MENOS
Y HAGAN MAS, QUE PROMETAN
MENOS Y TRABAJEN MAS
QUE DIGAN AHORA Y NO
MAÑANA.

Che

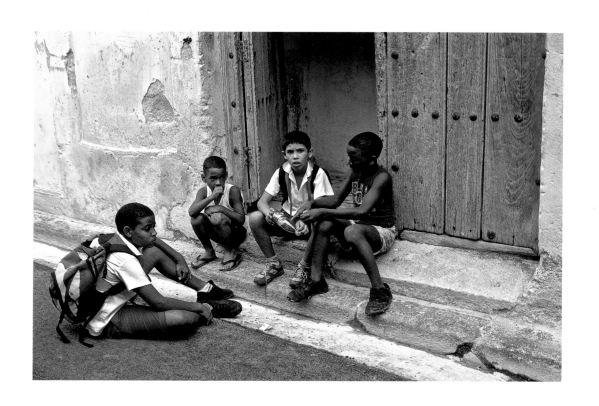

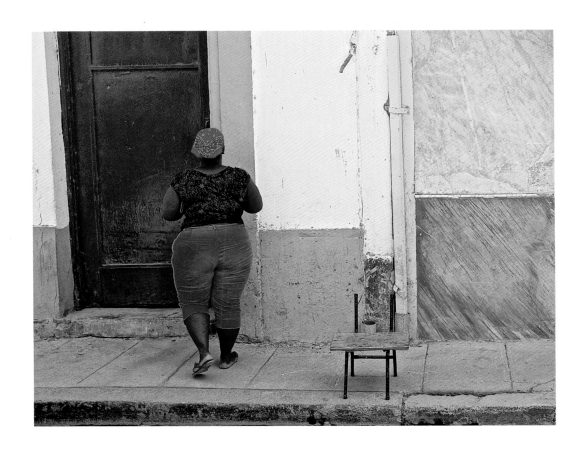

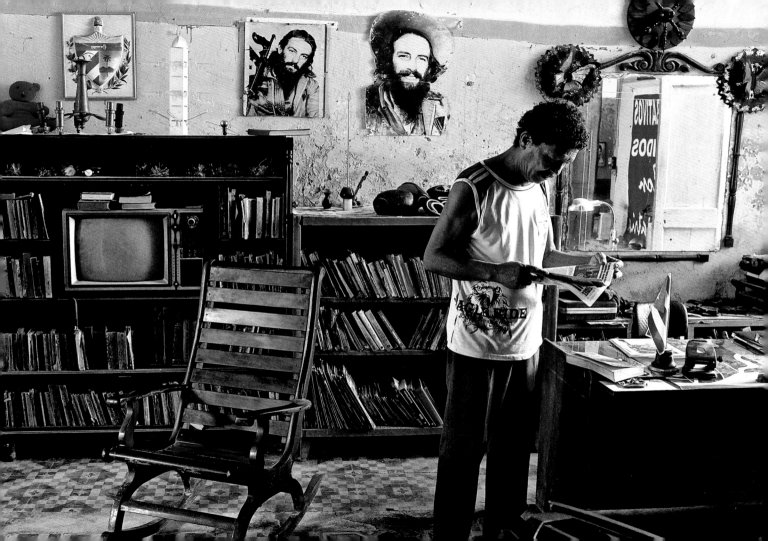

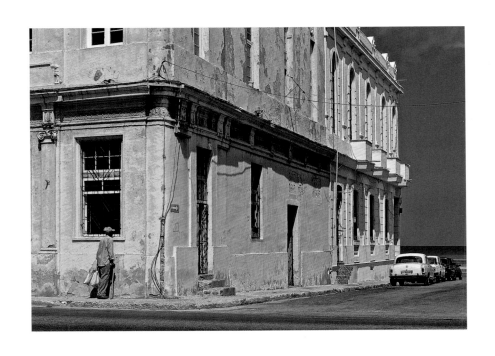

I made two visits to Havana not long before Castro died – first in 2014, to see it before it was irrevocably altered by the forces of history and geopolitics; second, a year later, because Havana, once tasted, is an irresistible drug. Armed with a Fujifilm X100 camera, a single fixed lens, and a spare battery in my pocket, I spent three weeks walking the streets of El Centro and Havana Vieja, the old districts, trying to capture the melancholy beauty and decay of the city, and the people who live there.

Some of it was familiar. I was born, and grew up, behind the Iron Curtain. I immediately felt at home with the way The System worked, or rather the way it did not. But where the palette of my homeland was dull, drab and irredeemably monochrome, here I found a treasure chest of visual epiphanies. I have always admired the American photographer Walker Evans; his photographs of Havana as it was in 1933 are indelibly printed on my mind, in black and white. But as soon as I stepped out of my *casa particular* at the golden hour, I knew that colour was not only my medium but my subject too.

Havana is famous for the ramshackle charm of its architecture, revolutionary icons of Che Guevara, 1950s American cars, courgette-sized cigars. All of these appear in my photographs – unavoidable clichés, and yet part of the city's fabric. As are peeling walls that swirl from tomato red to pink; schoolgirls in ochre skirts and crisp white shirts; aquamarine lintels against turquoise doors, and sienna torsos lit from within a doorway's shade. Federico García Lorca described it thus: "It is the yellow colour of Cadiz with a more intense shade, the rose of Seville almost red and the green of Granada with a light fish-like phosphorescence". Havana gluts the eye.

Witold Szabłowski, the Polish travel writer, says of the inhabitants of Havana:

> They stand in queues for taxis, for fish, for sugar and for flour. Magical, rickety old cars ferry them about to the remoter parts of the city, where prostitutes mingle with nuns, fishermen with book dealers, and lovers with people who never get so much as a hug these days. They sell flowers, cut hair, buy meat, or just a bone ... These are the Habaneros – people from a city that, in

their words, starts to wound you as soon as you're born, or in some cases even before that. Sometimes it embraces you, and sometimes it rejects you, like a bipolar mother who's stopped taking her pills ...

Szabłowski's vision of today's Havana is informed by a time spent there and his deep understanding of the invisible realities and rules of life under totalitarian system:

> ... When a wave floods the whole of the Malecón, [the coastal esplanade], striking against the breakwater with such might that it seems to want to break its way into the city, take it by force and drag it back to the times when the Spanish ships were anchored here, and instead of today's glazed look, the people's eyes were shining and full of faith that tomorrow would bring great change, a lucky chance, maybe a pot of gold, maybe a huge fish, as in the case of Santiago, the unfortunate fisherman in Hemingway's story. But what about today? Today they'd say on this sort of magical day, Havana is like the skeleton of the fish in Hemingway's story. You can still see vestiges of muscle, you can see

shredded bits of healthy meat, you can see the remains of fibres, you can see what a strong, healthy creature it once was, but now it's just a skeleton of its former splendour; just a fragile structure, across which someone clumsily lays cables to steal the electricity, someone sells stolen (or faked) cigars, someone puts on stockings to sell herself to the tourists, someone informs on a neighbour to get a better job, or to take possession of his flat; a structure across which they do their big, more often small deals, like scavengers stripping the skeleton of the fish ...

A harsh view, to be sure, and indubitably true ... My own response to Havana, however, was slightly different. I photographed her inhabitants as they sat in their open doorways, smoked, gossiped, drank rum, played dominoes, or simply waited. In the words of Sinclair Lewis (in his novel *It Can't Happen Here*), "so much of a revolution for so many people is nothing but waiting. That is one reason why tourists rarely see anything but contentment in a crushed population. Waiting, and its brother death seem so contented". And yet instead of pathetic victims of repressive regime, I mostly saw people who were

proud, resourceful, curious, handsome and friendly.

I did not always ask permission. Some knew that they were in the frame, others did not notice me at all. This small collection is not a cohesive document, nor does it claim to tell 'a story'. Rather, each image is a snapshot of a fleeting impression, a vignette, an evocation. The sleeping man in one picture, like so many, was a musician. "He sleeps all day and plays music all night", his friend explained. It was a privilege to be invited to the house they shared, rooms decorated with pictures of saints both secular and sacred. In the streets I stopped and talked to many. I don't remember any names for, foolishly, I did not write them down. Habaneros. Without their easygoing tolerance of my intrusive lens, this little book would not exist, and it is to them I dedicate it with gratitude and solidarity.

Marzena Pogorzały
2018

Havana de Cuba

First published 2017 by
Pallas Athene (Publishers) Ltd,
Studio 11a, Archway Studios,
25-27 Bickerton Road,
London N19 5JT

© Pallas Athene (Publishers) Ltd 2018

Text and photographs © Marzena Pogorzały 2018
The moral right of the author has been asserted.
www.marzenapogorzaly.com @ @Marzenaphoto

Editing and layout: Alexander Fyjis-Walker and Anaïs Métais

If you would like further information about Pallas Athene publications,
please visit our website: **www.pallasathene.co.uk**
or follow us: @ @Pallasathenebooks, @Pallas_Books, @Pallasathenebooks, @Pallasathene0

ISBN 978 1 84368 151 9

Printed in England by Park Lane Press